morphology

Anastasia Bamford

table of contents

difficult children

some stories don't
want to be told
the pen leaks
black stains on
fingers
marked for
being so foolish
as to be caught in
the act of
telling
how it was

they whine at
your mother's house
and when
everyone is watching
they fall down
screaming
for candy in
the grocery store but
only if
you have a full cart
and you really need
milk
still they keep growing
sullenly

assuming control
consuming the fat
moon
drinking it in
like the milk
that you walked
away from
until a river
of words pours
from leaky fingers
into the pen
spilling past you
in a hurry to be
grown

they solidify on paper
separate
beautifully complex

and you look at them
amazed
and think "damn
that's fine
how the hell
did that
happen!"

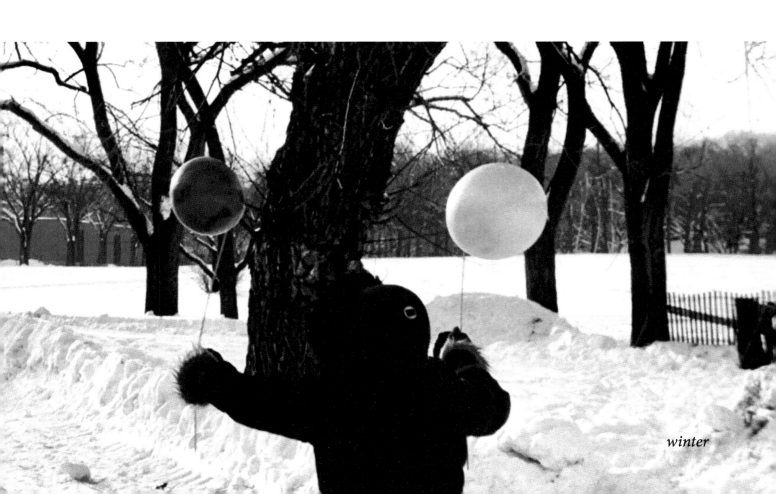

winter

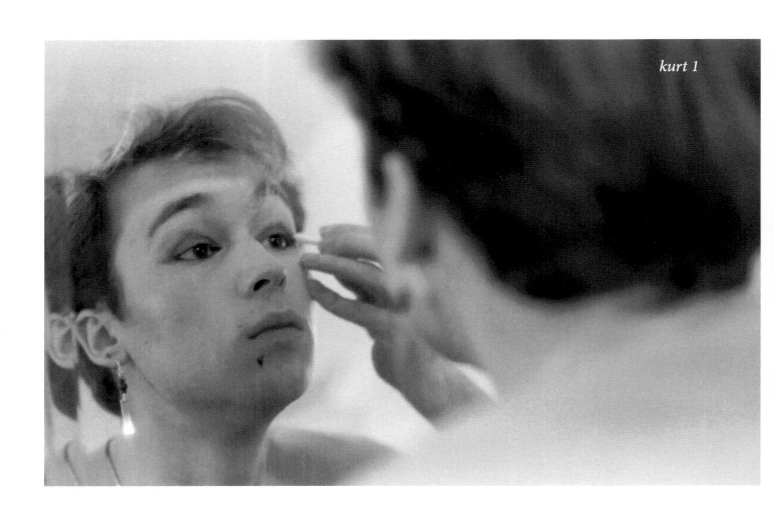

kurt 1

masks- for kurt

i watch
as the layers are
applied that
remove your masks

the slightest
tremble
of your shoulders
delicately strong

that was
never
fear
but ecstasy

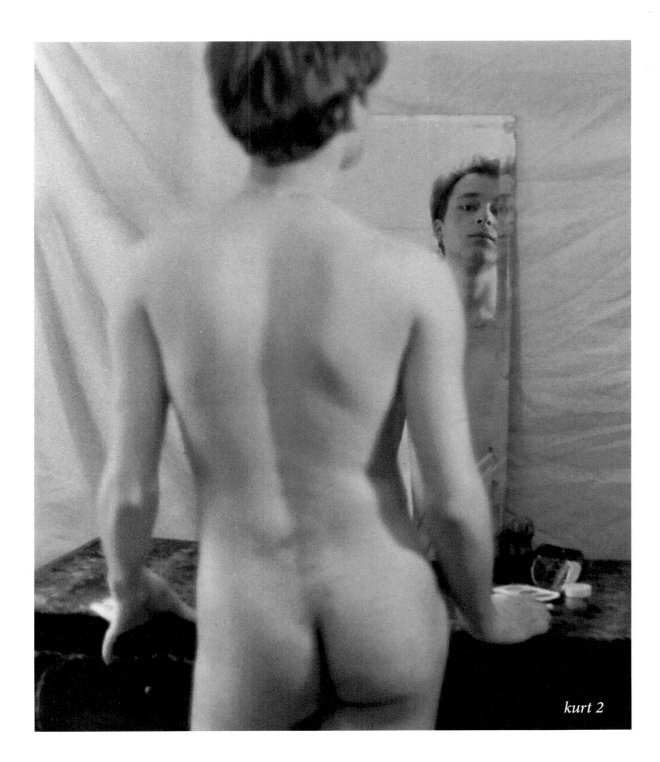

kurt 2

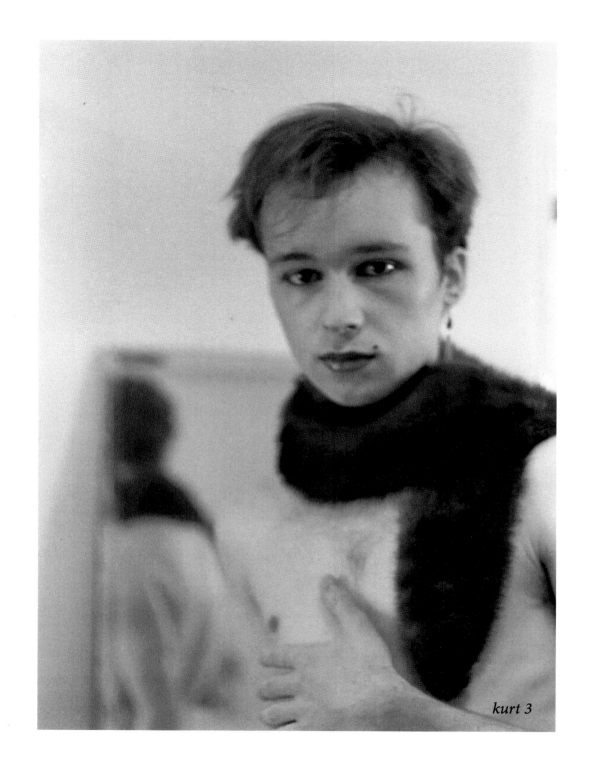

kurt 3

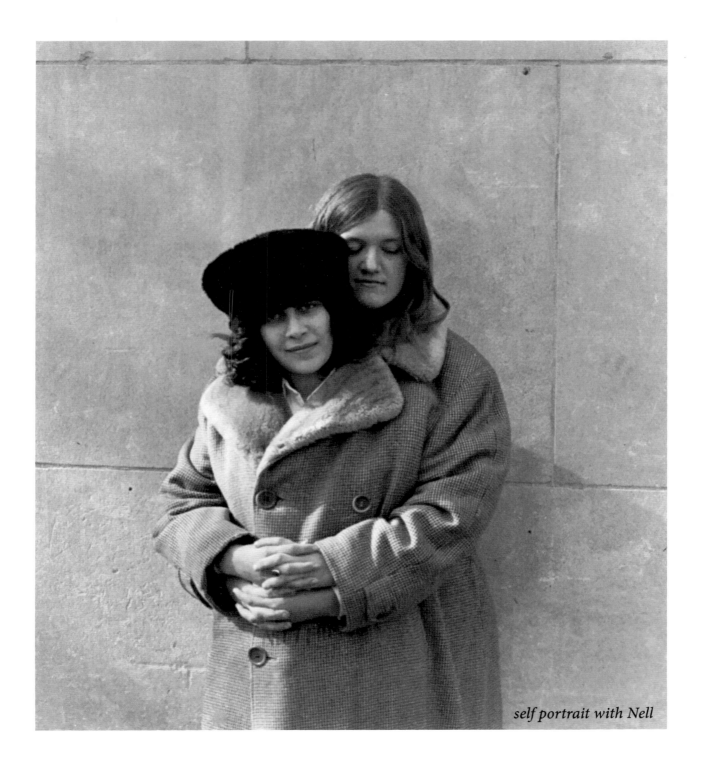

self portrait with Nell

the queering of duluth

musta happened
while i was
sleepwalking
thru my
mid-life crisis

there's a guy
in a shiny gold suit
and another in
a long skirt and
yet another
in pink rabbit leggings

i could try
to blame it
on homegrown
festival
but i think
we're just that
weird

now
when i see someone
tapping away
on their phone
i think -awwwww
they're writing poems
just connecting
to the flow

don't ask me why

if you ask me why
i am defensive or
angry
solitary
and distant

i will tell you
my best friend's
older brother
used to creep
into her room
and touch us
when we were 8

if you ask me why
i will tell you
when i was 15
and dared put on
a miniskirt for school
my own brothers
howled with laughter
"o my god, she has legs!"
if you ask me why

i will tell you
that when I was 19
and not really sure
if i was a girl or not
i was reading in a
quiet shady place
wearing overalls
and a man grabbed me
from behind
he tried to put
his hands inside my clothes
and i fought and screamed and
cried
he stopped and said
"i thought you would like it"

if you ask me why
i will tell you
that i stumbled to the bus
crying
terrified and furious
and on that bus full of people
no one
asked if i was okay
if you ask me why
i will tell you

that i rode that bus to work
the only place i could think of
and my dear friend christopher
sat with me and listened
and comforted me
until our boss
walked by and said
"well it sure wasn't
the way you were dressed"

if you ask me why
i will tell you
that one night
walking home from work
a car door opened
and a bunch of guys got out
tried to grab me
so i ran against traffic
across the street
down an alley
and hid behind garbage cans
while they searched for me

if you ask me why
i will tell you
that a guy from

the bar in town
where i had a beer
after work one day
followed me out to my farm
he tried to tell me
he was going to spend the night

"just a minute"
i said
and calmly walked
out into the other room
grabbed my short sword
off the wall
and came back
unsheathing it
ready
"no you're not"
i said
and he ran
right the fuck
out of my house
so don't ask me why

because i was 8
because i wore a skirt to school
because i was reading in a quiet place

because i was wearing overalls
because i was walking home from work
because i was followed home
because i was alive
and female.

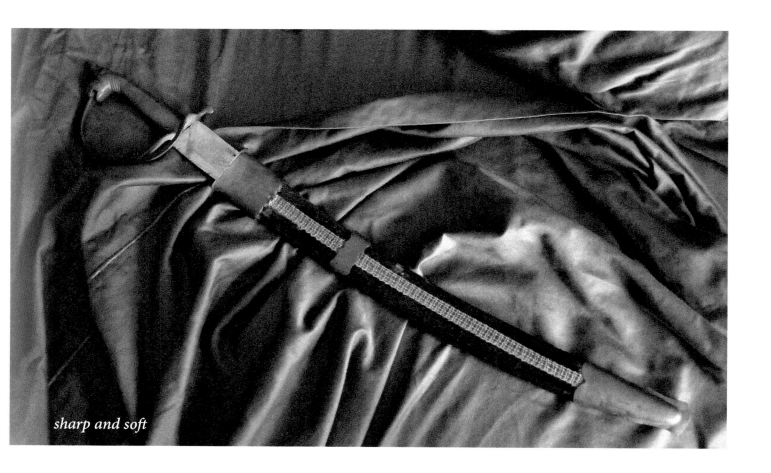

sharp and soft

the pirate marathon

as we hobble
towards the end
wooden legs swinging
all our injuries
and flaws
on display
some idiot hollers
"smile darling!"
and i flash
a devil's grin
sharp teeth
like tiny knives
waiting to carve
out your heart

yeah
i'm not your
darling

it's never a

good idea
to taunt pirates
we're prone to
unexpected displays
of our deepest desires
violence or lust
it can turn
either way

at the finish line
i see you
corset coming undone
and wicked smile
gleaming
and i can tell
how it's gonna be
this time

take me down
into the night
the sweet ship
rocking.

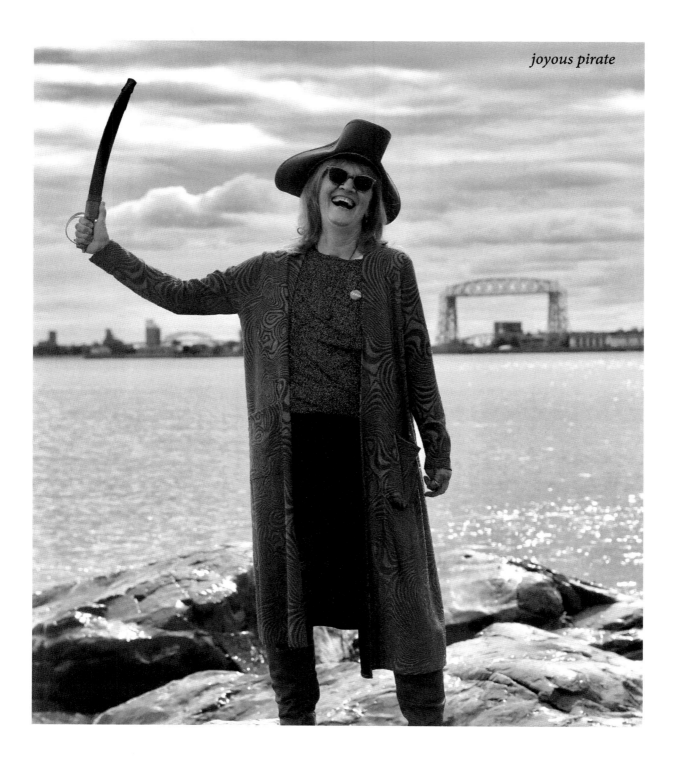

joyous pirate

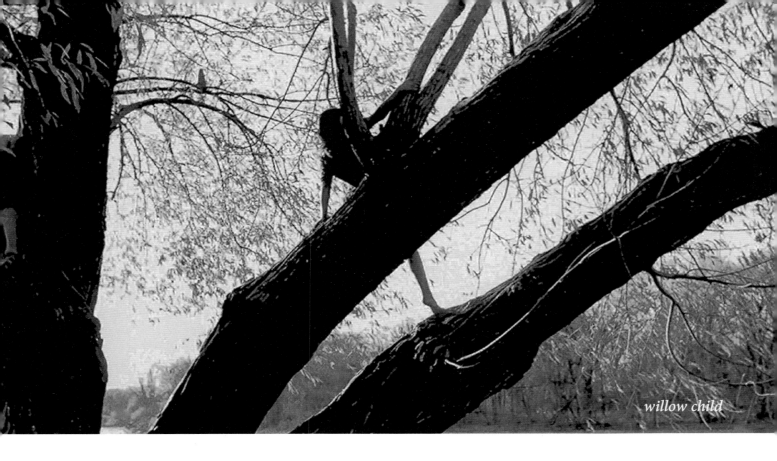

willow child

morphology

a stubborn solitary child
i was usually found
in a tree or
belly down in the dirt
studying the ways
of spiders
rocks
dewdrops
all the things
i knew myself
to be a part of
my mother

insisted
that i wear shirts
sent me to camp
with training bras
but
i could never
figure out what
i was training
for

when i developed
a woman's form
it horrified me
blood and breasts
and hairy places

slowly i accepted
that i had these aspects
like having a blister
or a broken bone that
never heals

i became an expert
in how to be

female without
being a girl
i did not want
to be a boy
i wanted to be
all the things
limitless

now
the older i become
the more things
i am
until one day
i will be only
everything
no longer
myself.

parisian tour guide

non binary star

everything
we revolve around
is non binary
the sun in it's lonely glory
blazing furiously
the uncountable other
stars out there
some few in
binary systems
but let's face it
the vast majority
are not

they
contain
and give rise to
the great diversity of things
trees
deserts
little winding creeks
crickets and beavers and starfish
all the creatures
we know and all
we can not

is it so
surprising then
that i should gaze
into my own depths
and perceive shimmering
multitudes

taking up space (farm girl)

just
walk on in
long dress swingin'
and shit kicker boots
all the guys
look away
and lick their lips
that nervous dog thing
that thing
the straight boys do
when i'm around

dirt under my nails
just letting
my body move
the way bodies do
breathing big
arms spread to
embrace the world
too big too focused
a silence
that's too loud
just too much
in every way
that counts

don't walk
like a farm girl
my mother used to say

well
why the hell not
isn't that
what i am?

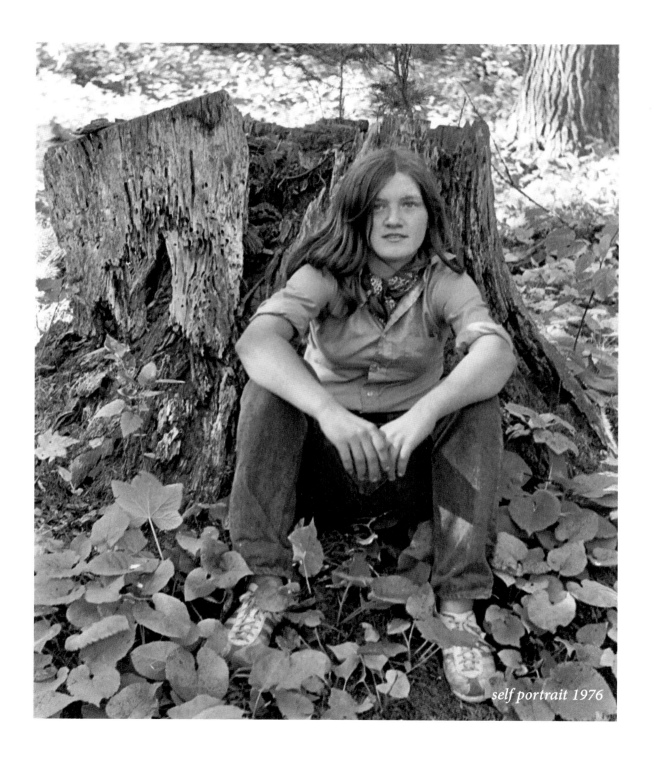

self portrait 1976

home growing

i'm learning
how to grow
friends
most of my life
it's something
i've been bad at

i'm not sure
what the right soil is
and watering schedules
mystify me
too much or
not enough
there must be
a happy medium

i was the
weird kid
the one who
was a horse
and tried to
tan mouse skins
voted
most likely to
be a freak
even in drama club

yeah
i know
that's sayin' something

but

earlier this week
people asked me
if i wanted to go out
after the poetry reading
so
instead of slinking
off into the shadows
with a lame excuse
i went out
and modeled
the behavior of
being friends

cycling

this
is the way
a new life begins

in the evening
the light lies softly on the land
corn stubble
glows pumpkin orange
blackbirds gather in the elm skeleton
noisily discussing flight plans

it is not
that the darkness will
not come again
in fact
even now it approaches

it is
that the great wheel
is turning
and now you stand
in the light

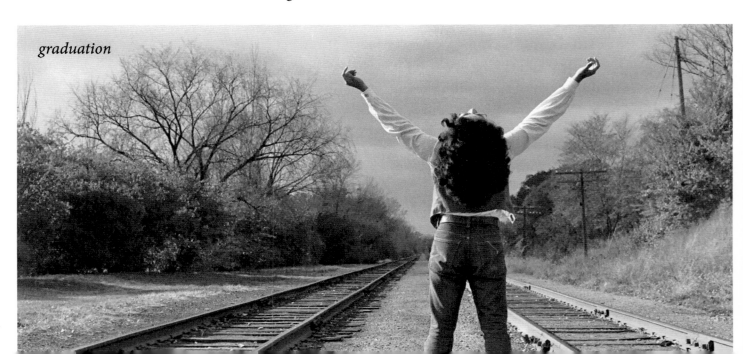

graduation

ole

she's sitting on
my back porch steps
like
some kinda
sami dharma bum
tweed beret and
sly smile
scandihoovian
trickster woman

i don't know what
she's all about
but
i suppose
she'll show me
soon

all i do know
are two things
first
her eyes are
a crow magnet
so full of light
second
my heart is seeking
shiny things

why i hate the state fair

the fun house isn't
it's not fun
and the tilt-a-whirl
sometimes
i just can't
figure out
how the hell
do i get
off this thing
so i don't get on it
in the first place
it keeps spinning
you see the faces
as they
whiz past
everyone's laughing
but
what is there
to laugh at

yeah
actually
i think it would

i must have
that serious look
on my face again
that one where
the guys say
would it kill you
to smile?

and the midway

is so damn peopley
full of that
sick smell
that mixture of
popcorn and old grease
spun sugar
sweaty sunscreen
spilled beer
babies are screaming
or laughing
i can't tell which
one it is
anymore
it's a long walk
back to the car

my body swimming
upstream
against the onrushing
people flow
i muscle onward
away from the fair
into the cool
depths
the trees and shade
of the world.

mahtowa, under cedars

ungazed

standing
on this rock
i feel the wind
and sun
as they touch me
everywhere

pink feet connecting
to pink granite
hair playing
with the breeze
that plays with it
in turn
skin in the sun
performing it's own
photosynthesis
of self

who is the one
looking out
when no one is
looking in

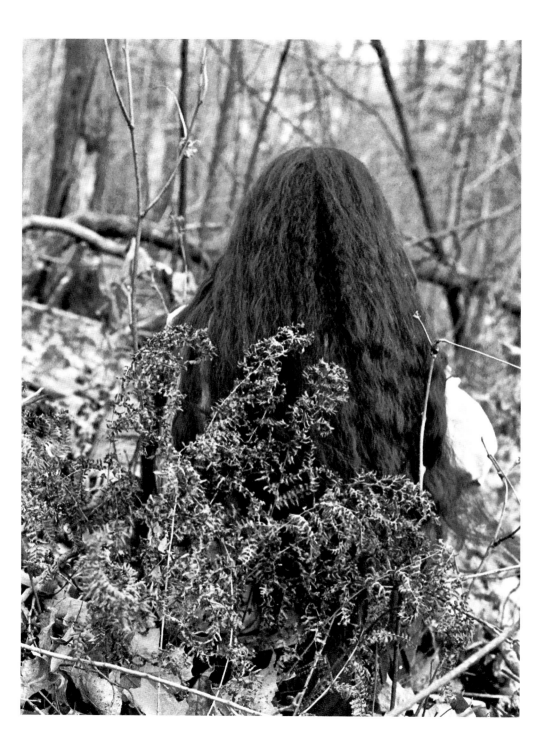

suzanne

amelia

reconnecting

been mostly
disconnected
for years now
so
tryin' to figure out
from this
old faded diagram
how you do this

insert tab A
into slot B
stand on your
head
and scratch
your ass
but then the
crease in the paper
obscures
what comes next

damn
this is hard
no wonder
i don't see
people
my dog
now she just says
food good
outdoors good
bellyrubs good

so
what i wanna
know is
where are all
the dog people?

sharp, not soft

winter burning

winter
nightsky
it's hard
bright and glittering
beautiful
in a violent way
it will suck
the marrow from
your bones
if you let it

the snow
looks so soft
but it squeaks
and crunches under
my boots
really
it's hard as hell
like my heart

when did i
become
so fierce
like the fire at
my feet
i'm only comfortable
at a distance

i don't think i
started out like this
but it's what
time and life
have made me
i'm not sorry
still
perhaps i should
come with a warning
danger
prone to
burning

the grey scale

i'm not
that colorful sometimes
locked into a
black and white
world

still
there is
great beauty
in the grey scale
the myriad shades
of transition from
shadow to light

lacking the
distraction
of saturation
sunlight
near close of day
streaming through
long grasses
takes on an intensity
closer
to my experience
of it

the ecstatic
flow of light
across my darkness
mirrored
in the shafts
flashing from
between oak leaves
and the spreading
ripples on black water
merging
with infinite white
of the sky

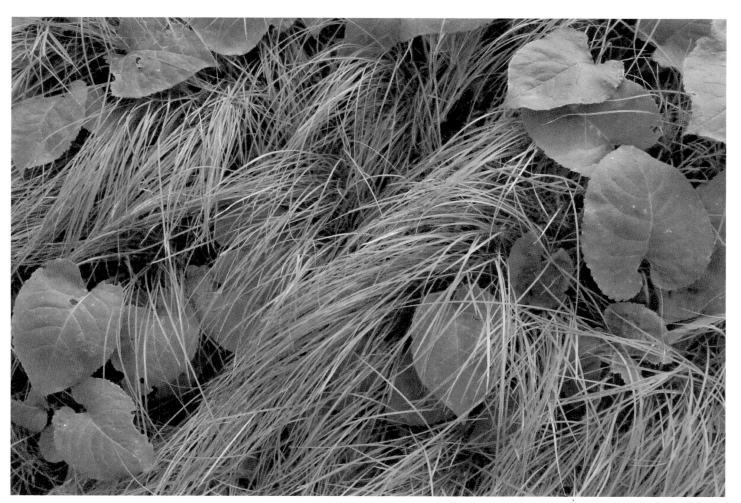

in the grasses

Acknowledgments

"Cycling" was previously published in the anthology Earth Beneath, Sky Beyond and "ole" was previously published in the anthology A Kiss Is Still A Kiss, both by Outrider Press.

"Masks-for kurt" and the photographs "kurt 1" and "kurt 2" were previously published in the Duluth Superior Pride Zine 2023.

The photograph "willow child" was previously published in the self published chapbook Dogwood Girl by Anastasia Bamford.

Author's photo and the photograph "joyous pirate" taken by Jess Morgan.

Graphic design by Sabrina Wertman.

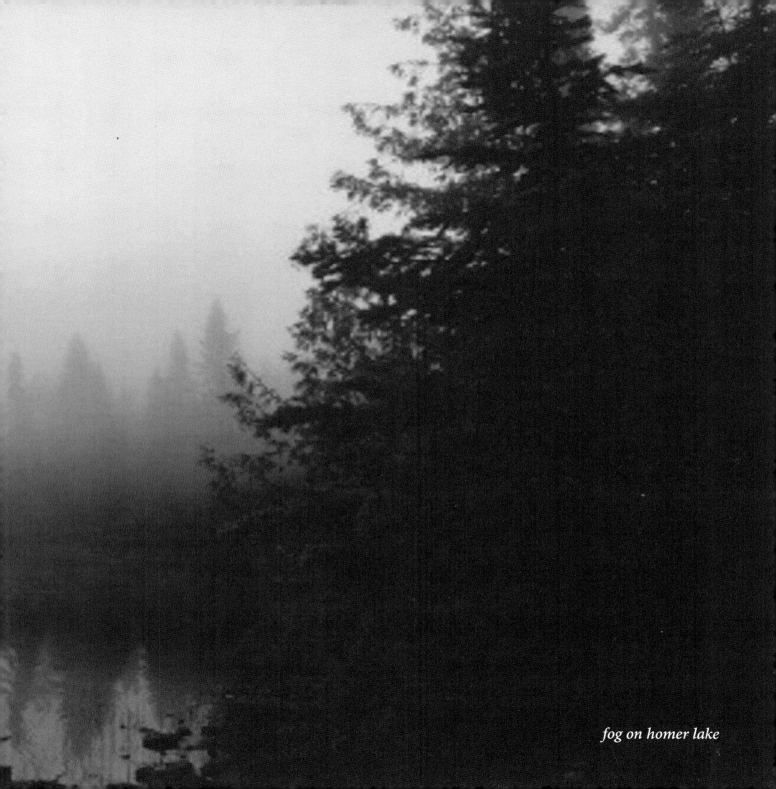

fog on homer lake

Anastasia Bamford has two self published chapbooks, *Rejoice* and *Dogwood Girl*. Their work has been included in the anthologies *Earth Beneath, Sky Beyond* and *A Kiss Is Still A Kiss*, both by Outrider Press, and in the *Duluth Superior Pride Zine 2023*.

Anastasia's influences include the boreal forest, photographers Robert Frank and Vivian Maier, poet Mary Oliver, and silence. They live in Duluth, MN with their dog Amelia, and their partner Ole.